Schirmer's Visual Library 2

Edvard Munch – The Early Masterpieces

The Norwegian artist Edvard Munch (1863–1944) pioneered a new style in modern art. His early masterpieces, created between 1885 and 1900, mark both thematically and formally »the end of an old and the dawn of a new epoch« (Joseph Beuys). Influenced by Naturalism, Impressionism, and Art Nouveau, Munch developed an independent Nordic variant of modern painting, whose intense emotionalism paved the way for Expressionism.
Munch's early paintings reproduced in this volume have their place among the masterworks of modern European art. In their aesthetic quality and psychological content they are only comparable to the paintings of van Gogh and Cézannes.
The introduction and the texts accompanying the illustrations were written by the Munich art historian, Uwe M. Schneede.

104 Pages, 34 color plates

Edvard Munch

The Early Masterpieces

Text by Uwe M. Schneede

W.W. Norton

New York London

The paintings reproduced in this volume are primarily found in Norway in the following public collections: National Gallery of Oslo: Plates 1, 3, 5, 7, 9, 10, 11, 13, 18, 25, 26, 31, 34 Munch Museum (Communal Gallery) Oslo: Plates 12, 14, 17, 20, 22, 23, 24, 28, 30, 32, 33 Rasmus Meyer Collection, Bergen: Plates 2, 4, 8, 21, 27, 29
Four additional paintings reproduced in this volume are found in the following museums: Art Museum Göteborg: Plate 19; Kunsthaus Zürich: Plate 6; The Museum of Modern Art, New York: Plate 16; The Paul Getty Museum, Santa Monica/Cal., Plate 15.

Cover painting:
The Scream, 1893
91 × 73.5 cm, National Gallery Oslo

Translation from German by Anne Heritage and Paul Kremmel

Reproductions: O.R.T. Kirchner & Graser GmbH, Berlin
Typesetting: SchumacherGebler, München
Printed and Bound in Germany

ISBN 0-393-30765-4

A Schirmer/Mosel Production
Published by W. W. Norton & Company
New York · London

Contents

Harmony Unattained: *Melancholy*

It could be a typical seaside scene if it weren't for the large male head, which, painted without depth, looms silhouette-like into the picture, half outside, half in, removed from the rest of the picture and yet evidently very much a part of it (Plate 9).

In a letter Edvard Munch called the picture *Jappe at the Seaside*. The reference is to a friend of his, the art and literary critic Jappe Nilssen; sketches indicate that the figures on the pier are the artist Oda Krohg and her artist-husband Christian Krohg. The landscape, a topographically faithful though somewhat simplified rendition, is at Aasgaardstrand, a resort in Oslo Fjord. There, in 1891, the three spent a few summer months together with Munch; the Krohgs and Jappe Nilssen bound together in a tense ménage à trois. Thus, the picture might reflect a personal experience: Jappe's jealousy of the harmonious couple in the background. But why, then, is the picture entitled *Melancholy?*

Munch, who made numerous diary entries in a somewhat fragmented style, wrote a note at Aasgaardstrand entitled »Melancholy at the Seaside«, which seems to refer to this picture and which could help to clarifiy it: »I was walking along the water ... Long, gray clouds on the horizon – a landscape of death – but now there is life below on the pier – a man and a woman were there – and then another man came – with oars on his shoulders – and the boat lay over there.« This confirms the autobiographical impetus for the picture but at the same time it is apparent that not Jappe Nilssen but Munch himself painfully experienced this landscape as one »of death«. The three figures belong to another world, a world full of life and hope. For in the background a departure is hinted at: »Ready to leave ... They move on – he and she – on their way to

the island over there – In the bright summer night they walk between the trees, arm in arm – The air is mild – it must be wonderful to love now.« The image, a vision of happiness, is reminiscent of an old topos, the departure to the island of love; the figure in our picture is left behind in pain, in a Dürer-like gesture of melancholy. »He was alone – the waves rolling monotonously towards him – splashing against the rocks.«[1] The conspicuously bright colors of the pier, the boat, the dress all signal the promise of life and love, from which the figure in the foreground is cut off, locked up in himself.

Munch's note makes clear that the concrete experience with Jappe Nilssen and the Krohgs triggered the scenario; but it is not the theme of his painting. Jappe is in reality Munch himself, and the painting is an expression of his desperate yearning, of his unfulfilled desire for happiness as the root of introversion and melancholy. It is a portrayal of the lonely individual, thrown back on himself; more specifically, the creative individual, to whom happiness is not granted and in whose inmost soul the conflicts with the outer world are fought out. These conflicts are expressed in the tension between the figures themselves, and between the figures and the landscape.

The subject of *Melancholy*, the isolated figure in the foreground, is more removed from than integrated into the rest of the picture. Although in fact part of the painting, he comes from without. Thus, the figure establishes a link between the world of the picture and the real world of the viewer. He presents his own story and at the same time addresses his problems to the viewer, arousing his interest. The inner unity of the picture is thereby broken. In *Melancholy*, for the first time, Munch introduces a mediating figure that plays two roles: inwardly he is the artist, whose isolation is depicted, while outwardly he is the direct partner of the viewer, to whom he reaches out.

This abrupt turning away from the picture was a late nineteenth-century reaction to the earlier part of the century. The subject is no longer embedded in and at one with nature in a romantic and religious way – nature is now seen as a menacing outer world (»landscape of death«). The subject, therefore, is located neither at the center of the picture nor in the middle of the pictorial space, but is cut off, on the periphery, turned away as in flight.

It was in *Melancholy*, created in 1891–92, that Edvard Munch developed his first great theme. The basic constellation, a subject estranged from the world around him in a »landscape of death«, is taken up again in *Despair* in 1892 and

is then incorporated in the four versions of *The Scream* (Plate 13). In these pictures the landscape finally becomes, as Munch described it, »a disturbed state of mind«.[2] Even the first critic to interpret *The Scream*, the Polish author Stanislaw Przybyszewski acutely perceived this aspect. He wrote in 1894: »It is a landscape of feeling, as in all of Munch's pictures. Such landscapes are only correlates of feeling ... His landscape is the absolute correlate of naked feeling; every vibration of the nerve exposed in the ecstasy of pain is translated into a corresponding feeling of color. Every sensation of pain is a blood-red stain; every extended cry of pain a streak of blue, green, yellow.«[3] The feeling of bewilderment and unattainable happiness is expressed in the pictorial constellation (the break in the inner unity of the picture) and in the color, the picture itself an inner portrait not requiring similarity with outward appearances.

The Kristiana Bohème of the Eighties: »Thou shalt write thy own life.«

We can see how this developed by looking at the early influences on Munch, which were more of an intellectual than of an artistic nature. Having grown up on the cultural periphery in a family whose piety bordered on bigotry, in 1884, seven years before *Melancholy*, the twenty-one-year-old Munch met up with a circle of artists and writers in Oslo who called themselves »Bohème«. Their meeting place was the Grand Hotel Café at Stortingsplass in the center of Oslo, then known as Kristiania. The circle's leading figure was the insolent writer Hans Jaeger, a recording clerk in Parliament, who ridiculed the values and moral principles passed on to Munch by his parents as the »life-destroying forces of society«. Of all the contentious and rebellious Oslo intellectuals, the enigmatic and captivating Hans Jaeger influenced Munch the most.

Jaeger's novel, *Fra Kristiania-Bohemen* (»From the Kristiania Bohème«), which was immediately confiscated after its appearance in 1885 and led to the author's imprisonment, describes in provocatively frank language a rebel against middle-class mores and a messianic socialistic vision of a utopia where people lived together freely on the basis of what he called free love. For Jaeger

the institutions of state, church, and marriage stood in the way of individual freedom. He demanded political, social and sexual freedom as well as the right to commit suicide. Munch confessed later: »No other book ever made such an impression on me«,[4] and the Swedish writer Ola Hansson confirmed in 1891 that it was »the most brazen book« that had »ever been written in the North«.[5] Despite the dubious literary value of the novel, Munch was no doubt fascinated by the freedom of expression, the bold attack on the bourgeoisie, the rejection of all moral norms, and the liberation from the intellectual restrictiveness of Oslo.

Another declaration of Kristiania-Bohème principles can be found in the nine bohemian commandments printed in the eight issue (February 1889) of the periodical *Impressionisten* (»The Impressionist«), first published by Christian Krohg and later by Hans Jaeger.

1. Thou shalt write thy own life.
2. Thou shalt sever family ties.
3. Thou canst not treat parents poorly enough.
4. Thou shalt not beat thy neighbor for less than five kroner.
5. That shalt hate and despise all farmers like Bjørnstjerne Bjørnson, Kristoffer Kristofersen and Kolbenstvedt.
6. Thou shalt never wear celluloid cuffs.
7. Thou shalt never forget to cause a scandal in the Kristiania Theater.
8. Thou shalt have no regrets.
9. Thou shalt take thy own life.

Of all the sarcastic rhetorical attacks on bourgeois morals, anticipating the avant-garde movement of the twentieth century, the aesthetic directive, »Thou shalt write thy own life« was the most important for Munch. In a letter to the director of the National Gallery in Oslo, Jens Thiis, Munch later explained that it was not necessary to look very far to understand the origin of his art: »You will find the explanation in the bohemian period. It was important then to paint real life as well as one's own.«[6] At a time when historical landscapes and cozy folk-scenes dominated the official art-life of Oslo, the bohemian demand for subjective representation of experienced reality fell on fertile ground in Munch.

In his court defense, Hans Jaeger repeated a metaphor which gave expression

to this desire and which Munch used as well. Jaeger said that his book had been written with his »heart's blood«; this was its legitimation. Munch took the same metaphor of creative activity fed by and consuming the inner substance and raised it to a general principle: »All art and literature, like music, must arise from the blood of one's own heart«.[7] This metaphor evokes the idea of sacrifice, which for Munch results in a new definition of the artist's role.

Not nearly as vocal as the others, Munch was a withdrawn figure on the periphery of the Kristiania Bohème, absorbing everything and thereby falling into deep conflict with his puritanical upbringing. »This Jaeger«, he wrote, »he was tough – you know what he said – strike him dead – my father ... I couldn't understand Jaeger. I loved him but I also hated him.«[8]

When in 1889, aged twenty-six, Munch incautiously displayed his entire 110 works in a one-man public exhibition – the reaction was as might be expected – , he gave the portrait of Hans Jaeger (Plate 5), finished shortly before, a central position, thereby not only avowing Jaeger's ideas but also expressing solidarity with him as a person. Jaeger had just been released from prison and was regarded as an outcast.

»Thou shalt write thy own life.« This motto, first printed in 1889 but discussed long before in the Kristiania-Bohème circle, was adopted by Munch very early on. It is both literally and figuratively present in *Melancholy*. In the mature works that preceded *Melancholy* – among them *The Sick Child* (Plate 3) – Munch was dominated by it. The freedom of expression found in these works is the consequence the bohemians envisioned in »writing thy own life«.

Reliving the Past on Canvas: *The Sick Child*

In the Winter of 1885–86 Munch finished three paintings whose controversial themes can only be understood in connection with the bohemian influence: *The Sick Child*, *Puberty*, and *The Day After*. The last two were destroyed by fire and are only preserved in subsequent versions (Plates 3, 11, 10). Munch later wrote: »There are many painters who have painted sick children

propped up against pillows. But it was not the motif that was behind my ›Sick Child‹. No, in the ›Sick Child‹ there was no other influence at work than a childhood remembrance. These pictures were my home and childhood. I insist that none of those other painters experienced this theme to the last cry of pain as I did in *The Sick Child*.«[9]

This is the key to the picture. What is depicted is a past but not yet fully worked out experience: the death of his sister Sophie, which had deeply affected the 14-year-old Munch. At the age of five he had already witnessed the death of his mother. »Sickness and death were a part of my family. I have never got over the unhappiness I felt then. It has also been a major force in my art.«[10]

The motif is familiar and was often treated emotionally, if not sentimentally by many painters in the second half of the nineteenth century. But what startles even today is the jagged surface of Munch's painting with its visible traces of impulsive and forceful work. Damp, nearly dry masses of color, applied in several layers, were scraped off again, carved, notched and scratched; Hans Jaeger attested that Munch reworked the portrait some twenty times. We can imagine a passionate and painful struggle with the canvas and paint. The visible marks in this work counteract the descriptive elements if, in fact, they do not destroy them. Has not the picture's very structure taken on meaning?

Munch said that he experienced this theme to the last cry of pain. The emphatic way he painted appears to be a symbolic act of freeing himself from persisting emotional distress. Munch spoke of »inspired and hasty reworkings« that were comparable to »nervous release«,[11] which explains the »powerful, moving impression« the picture gives us. The act of painting has taken on here an additional function: remembering and resolving painful memories. In the late 1920s Munch recalled, »I painted impressions from my childhood – the blurred colors of that time.« Even toning down colors to gray takes on symbolic character here, comparable to the haze which envelops the past. »By painting colors and lines and forms that I had seen in troubled times – I wanted to let the troubled sounds vibrate once again as with a phonograph.«[12] Not the real experience is recalled but the »sounds«; the traumatic experience must be resolved. In Munch's own words: »I do not paint what I see – but what I saw.«[13] Thus, to counteract memory-loss in an age where time passes too rapidly, art's memorial character is brought into play.

Here color and canvas have become objects through which the personal element is directly recorded in »nervous release«. Pain and helplessness find their expression in the pictorial materials which, no longer mere vehicles, now speak for themselves. Munch later described this painting as his most important. In fact, it marks a turning to modern art; it is a transitional work from art as representation to art as invention. For Munch – as well as for his contemporary Vincent van Gogh – the motif alone is not able to express the suffering; the pain, and that which is not yet expressed, can only be formulated and conveyed if in the process of developing the motif the materials are also renewed – if the language is developed anew from that which is expressed. It is at precisely this point that a rift emerged between artist and public for the language of pictorial materials is groping and experimental, opposed to the traditional and to those artistic skills which comfortably remain within accepted conventions. We need only recall the early reactions to this picture. In 1886 the *The Sick Child* was shown at the Autumn Exhibition in Oslo. »On the opening day as I entered the room in which it hung«, reported Edvard Munch, »people stood en masse in front of the painting – shouting and laughter could be heard.«[14] The critics' anger was directed not at the motif, which was described as being quite »pretty«, but at the form of expression. The basic criticism, which appeared in all newspapers and was later applied to other pictures, attacked the execution: the picture was smeared on the canvas, an unfinished conglomeration of blotches of paint, poorly executed. It was thus a »scandal« to have presented it to the public as a work of art. The deviation from a descriptive, representational form was viewed as a rebellious act, the exploration of new aesthetic terrain as insidious mockery of morals and decency. And even if his intention was not malicious, such a painter was completely incapable of producing a work of art.

Munch wrote of his critics: »They do not understand that these pictures were painted in earnest – in suffering – that they are the result of sleepless nights – that the price was someone's blood, someone's nerves.«[15] Munch insisted that his work grew out of painful experience, that a work of art is justified because it emanates from suffering and speaks of this suffering in the most personal terms. »You know my pictures«, he explained, »and you know that I have experienced it all.«[16] Such confessional art, such subjective authenticity – following the first bohemian commandment – breaks away from all forms of

historicism, goes beyond conventional art expectations (which is why it was viewed as an open provocation), and with its freedom of expression and renewal of artistic language paved the way for modern art.

Paris 1889–92: Inspiration

After the academies in Munich and Düsseldorf had lost their importance, Scandinavian artists of the 1880s' often spent at least a short time in Paris, to escape provincial Stockholm or Oslo for the Paris world of art moulded by Courbet and Zola, Baudelaire and Manet, the Paris of boulevards and cafés, salons and rival salons, galeries and art-schools. Since there was no academy in Norway, the government introduced scholarships in 1880 to enable artists to live abroad. With the help of such a grant Edvard Munch lived in France from 1889 to 1892, most of the time in Paris but also in nearby Saint-Cloud.

There is no information about what new art he saw or what impressed him but it is safe to assume that he at least encountered works by Vincent van Gogh and Paul Gauguin; he certainly went to the large exhibitions and galeries. In March 1891 he no doubt read the controversial article about Gauguin by the art critic Albert Aurier in *Mercure de France*, which focused public attention on the Post-Impressionist movement. Aurier wrote that the true aim of painting could no longer be the exact reproduction of objects; ideas had to be expressed, using a specific pictorial language, that is to say, in characteristic, simplifying forms. »The artist always has the right … to exaggerate, diminish or deform these characteristic elements (form, line, color, etc.) … depending on what the depiction of the idea demands«. In this way the »ability to evoke feeling« must be cultivated so that art makes »the soul tremble before the surging drama of the abstract.«

These were evidently important impulses for Munch as were the ideas of the Danish poet Emanuel Goldstein, a friend of Munch's in Paris. Well-versed in theory, Goldstein wrote at this time that naturalism is only a craft, reality must be used symbolically »the poet shall produce his reality himself.«[17] Mood and ideas should predominate – an antinaturalistic approach that had a strong impression on Munch.

His sketchbooks from the Parisian years display an abrupt juxtaposition of old and new. On one page there is a conventional representation of everyday observations, on the next page one discovers ideas compactly transposed into pictorial forms, following Gauguin, Aurier and Goldstein, from which, during the following years in Berlin, the great paintings of the »Frieze of Life« were to develop. Here it becomes clear that the breakthrough did not occur in Berlin, as has been previously assumed; the ideas for the paintings originated in Paris; they were carried out in Berlin.

Similarly, van Gogh experienced decisive impulses between his Dutch and southern-French phase during his stay in Paris from 1886 to 1888; these hardly came to the fore in his Parisian works but clearly emerged in Arles and later in Saint-Rémy and Auvers-sur-Oise. For Edvard Munch, who from 1889 to 1892 first experienced the rich, pace-setting Parisian art-scene, the years in Paris can be viewed as a pivotal period between the earlier experimentation of Oslo and the significant works of Berlin which were incorporated in the »Frieze of Life«.

Berlin 1892/93: The Munch Affair and the »Ferkel« Circle

In 1892 Edvard Munch received a surprising invitation from the *Verein Berliner Künstler*, Berlin's influential artists' society, for a one-man exhibition; it was surprising because the society did not usually exhibit the works of living painters nor was it – under its director Anton von Werner – in the least receptive to anything modern. While symbolism and the new spirituality were the current topics in Paris, in Berlin Naturalism was still under attack and historical painting, a buttress of the established order, was celebrated. Conflict was inevitable. Munch exhibited 55 paintings including the *Sick Child* (Plate 3), the *Portrait of Hans Jaeger* (Plate 5), the first version of *Melancholy* and *Night in Saint-Cloud* (Plate 7). »Now the exhibition has opened«, Munch reported home, »and it has created a huge scandal – there are a number of wretched old painters here who are enraged about the new movement – The newspaper reports are deplorable«.[18] In fact the exhibition produced an uproar, the likes of which the art scene in Berlin had never witnessed before. A few days later Munch wrote: »It's hard to believe that something as innocent as painting can

cause such an uproar.«[19] The newspapers and magazines were full of comments like: The paintings were »smeared together in the most slipshod way«, »the crude work of a house painter«, »grotesque aberrations«; »there was no point in wasting any more words on them, because they had nothing to do with art.«[20]

The *Verein Berliner Künstler* decided to close down the exhibit forthwith »out of respect for art and sincere artistic endeavors and in the understandable desire to prevent the *Verein Berliner Künstler* from being associated with a venture not worthy of the society.«[21] What broke out in the Munch scandal was a feud that had been brewing in Berlin for some time about new forms of art. Even the journal *Kunst für Alle* (Art for Everyone),[22] which was not exactly noted for its progressive attitudes, commented, »It is not the untalented artist who is being condemned here but the modern artist«. Patriotic values were to be upheld; the works of Gerhart Hauptmann, Max Liebermann and Käthe Kollwitz were openly condemned by the Kaiser as »art of the gutter«. Arnold Böcklin and Max Klinger were also fiercely attacked. In addition, established artists had a vested interest in maintaining their share of the limited art-market in Berlin and in keeping out the ever increasing number of younger artists as well as the artists from France and Scandinavia.

Edvard Munch was partly dismayed, partly elated: »I couldn't have received better publicity.«[23] From then on the scandalous artist from the north was the talk of the town. After the exhibition had created a sensation in Cologne and Düsseldorf, Munch, in a characteristic display of obstinancy, decided to risk another attempt in Berlin, this time independent of any institution. He rented rooms in the »Equitable Palast« in Friedrichstrasse, a centrally-located, bustling area of Berlin, where in December 1892 he presented the same collection of paintings, to which he had added his portrait of Strindberg. No other painter in Berlin was as controversial and well-known as the thirty-year-old Norwegian. Munch decided to stay in Berlin.

And he found there a new intellectual home. In a Weinstube in the new Wilhelmstrasse near Brandenburg Gate, which Strindberg called »Schwarzes Ferkel« (black piglet), a circle of Scandinavian writers and artists met – among them Strindberg, Sigbjørn Obstfelder, Ola Hansson, the Finnish painter Akseli Gallen-Kallela, Gunnar Heiberg and Christian Krohg from the Kristiania Bohème as well as Stanislaw Przybyszewski and a few young Germans

such as Richard Dehmel, Max Dauthendey and Julius Meier-Graefe. The
»Schwarze Ferkel« quickly became a well-known intellectual center, its most
prominent figure being the notorious playwright August Strindberg. And,
according to Przybyszewski, »Somewhere in a corner the great visionary
Munch sat brooding over a glass of whisky.«[24]

The critical, free-thinking Scandinavians were making their mark in Berlin;
the »Ferkel« became the center of a new movement. Subjectivism, as they saw
it, provided the means for exploring the soul and the unconscious. At the
same time as Sigmund Freud was beginning to develop the foundations of
psychoanalysis, the young rebels in the »Ferkel« circle were focusing their
attention on investigating the depths of the psyche.[25]

Munch was caught up in this circle from the very beginning. When Sigbjørn
Obstfelder talked of the subject as aesthetic category, Strindberg of the power
of phantasy, Dehmel of the need to arouse the beholder's imagination and
Przybyszewski of art's provocative character, they all confirmed Edvard
Munch in his approach. The discussions and debates of the »Ferkel« circle as
well as the awareness of participating in a new start had a liberating effect;
Munch found encouragement to resolutely pursue his own style in his paint-
ings, many of which were created in Berlin.

The Project of the 1890s' »The Frieze of Life«

The conflict between the sexes, the memory of death and illness, and existen-
tial hardship are the themes in Munch's art of the 1890s'. Within a scenic style
of painting he created configurations of suffering and estrangement. His
often impulsive manner of painting forgoes detail, thereby suspending the
temporal and gaining symbolic force. Munch, however, soon realized that the
subjective character of his paintings made them difficult to understand in
isolation and that only by juxtaposing his motifs of life and death could full
justice be done to his perception of the world. »What I now plan to do,« he
wrote a Danish friend in 1893, »will be different. I must ensure that my works
take on a single stamp… At the moment I am working on studies for a series
of pictures.« He then mentions several of his completed paintings and adds:

»They were quite difficult to grasp, I believe – when they are all brought to-gether they will be easier to understand.«[26] This marks the beginning of the »Frieze of Life«. Munch also notes here that the series would »deal with love and death«. Thus, at the beginning of 1893 his general theme had been set. The »Frieze of Life« – a title he first used in 1918 – was to become Munch's predominant artistic project during the 1890's. The plan was never complete-ly carried out and Munch's ideas of an optimal presentation never realized, but he was able to show in several exhibitions what he was striving for.[27] In 1893 for the first time he presented six works together under the common rubric »Studies for a Series: Love«; these were *Melancholy* (Plate 9), *The Kiss* (Plate 28) *Vampire* (Plate 19), *Madonna* (Plate 22), *The Voice* (Plate 14), and *The Scream* (Plate 13).

The underlying tone is much less one of love than one of pain. The subject of the »Frieze of Life« is unfulfillable love, but this also includes isolation and death, the inevitable consequences of union. Munch noted: »Just as Leonardo da Vinci studied the inside of the human body and dissected corpses – so do I attempt to dissect the soul. – The record of what he did had to be written in code, because it was punishable to dissect corpses – Today it is the dissection of the human psyche that is considered immoral and irresponsible.«[28]

The following year Munch grouped together fourteen paintings in Stock-holm under the title »Studies for a Series of Mood Paintings: Love«. The new additions were: *Woman in Three Stages* (Plate 21), *Ashes* (Plate 18), *Metabolism, Hands* (Plate 20), *Starry Night* (Plate 15), *Young Woman Embracing Death*, and *Anxiety* (Plate 23). The recurring themes in these paintings included longing for love and union, fear of the destructive power of love, and, as Munch expressed it, that »love goes hand in hand with death«.[29]

At this time entirely new pictorial concepts emerge, as in the painting *Jealousy* (Plate 29). Here a spatial continuum is lacking; the scale changes abruptly. The scene on the left side of the picture is the inner reality of the figure in the foreground, which also means that the beholder must put himself in this fig-ure's place in order to grasp the contextual relationship. Within this synthetic pictorial constellation, it is the large head, as in *Melancholy*, that enables the viewer to identify with the inner world of the picture. The face is portrayed as open and revealing, torn by inner conflicts; this allows access to the inner,

intimate sphere. What is here depicted is not friendship and jealousy, but inner conflict and distress.

Isolated by a portion of a wall on the left, a red flower can be seen, Munch's »blood-flower«, inspired by a Goldstein poem. For Munch the blood-flower points to the role of the artist, in keeping with his idea, mentioned above, that art arises from the heart's blood. The depiction, or better the creation of happiness, seen in the foreground as a picture within the picture, necessarily presupposes renunciation. The blood-flower is for Munch the artist's symbolic attribute; an artist that suffers existential pain in order to envision in art a happiness that he himself cannot participate in.

In 1895, for a further exhibition at Ugo Barochhio's in Berlin, Munch expanded his »Frieze of Life« to include *Evening on Karl Johansgate* (Plate 8) and *Separation* (Plate 30), and in 1902, in connection with the Berlin Secession, *Death in the Sickroom* (Plate 12), *Red and White, Jealousy, By the Deathbed* (Plate 27), *The Red Vine* (Plate 33), *The Dance of Life* (Plate 31) and several other works. In 1902 at the last great exhibition there were a total of 22 paintings, before the series was broken up when the works were sold. Under the general title »Frieze: The Presentation of a Series of Images of Life«, the works were grouped together along the four walls of the gallery according to the themes »The Seeds of Love«, »The Blossoming and Fading of Love«, »The Anxiety of Life«, and »Death«. In a general description of the series that Munch wrote around 1894/ 95, there are references to the individual paintings: »These pictures are atmospheric impressions of life and the soul, and together show one aspect in the struggle between man and woman, otherwise known as love. Of its beginnings, where it is rejected … then … Kiss, love and pain, where the struggle has begun … The woman who gives herself and assumes the pained beauty of a madonna – the mystique of an entire development compressed together – the woman in her many-sidedness is a mystery to man – The woman, who is at once a saint, a whore, and unhappily forlorn. The woman's hair has become entwined and wraps itself around his heart. The man is very disturbed by this struggle – … the mood is insane – Nature appears to him as one great scream, with blood-red clouds like drops of blood … Lust.«[30]

In the late nineteenth century the idea of a cycle of paintings is frequently met with. Van Gogh pursued the idea in Arles and evidently also in Auvers-sur-Oise, shortly before his death. Max Klinger wrote about the subject in his

article »Painting and Drawing« in 1891, and Gustav Klimt, a member of the Vienna Secession, carried out the idea in his *Beethoven Frieze* in 1902. Many of these artists including Munch took for their model the decorative tableaus of Puvis de Chavannes. This trend arose from the artists' dissatisfaction at the detachment of individual paintings from their context in the wake of an expanding art market and of mass exhibitions where people came merely to pass time. Furthermore, these artists were concerned that their paintings, viewed individually, might not be understood. As a result, an increasing number of artists sought refuge in an all-embracing idea of art in which the ultimate goal was to incorporate their paintings in the interior design of a building.

Munch's aim is expressed in two texts written before 1918: »My idea is that the frieze be hung in one room in a suitable architectural setting so that each picture can stand on its own without detracting from the impression of the whole. Unfortunately no one has been willing to carry out my plan so far.«[31] Further: »My idea was that the paintings would decorate a house of several rooms. The pictures of death could then be hung together in a small room, either as a frieze or as a large wall panel ... And couldn't there be a connection between this room and the frieze with motifs of the seashore and forest which decorate the neighboring room?«[32] He added, with resignation and not without irony, that no doubt the best surroundings for his »Frieze of Life« would be a castle in the air.

Munch rejected the criticism that these pictures did not really make up a cycle because of their varying size and special conception. He felt that these variations helped to prevent uniformity and monotony: »I don't think that the frieze has to be made up of equally large spaces. On the contrary, I feel that the varying sizes add more life.«[33] Munch stressed the common, linking elements: the line of the seashore, the basic structure of vertical lines (trees) contrasted with horizontal lines (seashore), the unity of mood and colors.

Munch envisioned an integrated work of art, fused together from congruent but disparate elements, arising from an acute relationship to the world, from, as he himself said, »the modern life of the soul«. But when he spoke about a »Chapel of Art«,[34] he obviously meant more. He was referring to a consecrated place for his works, which would leave a unified impression on the viewer resulting from the unity of space and pictorial art. In the late 1920s Munch

commented on the ideal location for his »Frieze of Life«: »People will be able to understand the sacredness and powerful force in the paintings and they will remove their hats as if they were in church.«[35] Ever since Philipp Otto Runge expressed his desire for a festive rotunda for his cycle entitled *Times of the Day*, artists have dreamt of such purified sites for their art, select places of contemplation, where art can lay claim to a transcendence previously reserved for religion. Munch's chapel is to be understood as a place where the »modern soul« as shaping force can stand up against the fortuitousness and the shallowness of reality, as a place where it becomes clear that the only true knowledge of reality is obtained through the artist's perception: the soul as covert object of worship, art its manifest form.

The individual's estrangement from the world, as expressed in each painting of the »Frieze of Life«, is symbolically resolved in the unity of the entire work by the cathartic function referred to above in the idea of a chapel of art. What has been lost due to the art-market and mass exhibitions is to be regained by the aura of sacredness, namely, the higher truth in art. Not all art can be included here; only those forms of art that express the »modern soul of life« and which in their intense subjectivism exhibit an aesthetic autonomy.

Beginning of a New Epoch

Joseph Beuys once said, »Munch's symbols of dying can be directly understood as references to the end of an epoch and the beginning of a new one.«[36] As in Vincent van Gogh's paintings, in all of Munch's works there is a subjectivism, a renewal of themes and pictorial means of expression, and an expression of estrangement from the world; all this Munch unerringly pursued in the face of continued objections and fierce criticism. Whereas van Gogh proceeded to destroy himself mentally and physically, Munch was able to start a new productive period after a severe nervous breakdown in 1908. Van Gogh envisioned a future era which he knew he would not live to see, but which he wanted to help pave the way for. Both Munch and van Gogh had a vision of a brighter future in contrast to the darkness of their fears. What, in their opinion, could art do to help fulfill this dream?

Like van Gogh, Munch often thought about the problem of the artist at the beginning of the modern era: »My art has its roots in thinking about how I can explain the discrepancies between myself and life – Why wasn't I like other people? Why was I born without having been asked? This curse and my reflections on it became the basis for my art. Its strongest basis and without which my art would be completely different. – However, in these reflections on the impetus for my art lay also the desire and wish for my art to bring light – darkness and also light to mankind.«[37] He experienced life as a curse; only in and through art could the curse be broken, could life be given meaning. Munch sought meaning not only for himself but for others as well: »I thought I could help others understand their own lives.«[38] By visualizing the hidden, unspoken conflicts he wanted to achieve a purifying effect: »Darkness and light for mankind.«

The »Frieze of Life« was an ambitious attempt to carry out this process of clarification and thereby to realize his ideal of responsibility in art. In the »Frieze of Life« he has left an old era behind and paved they way for a new one by resolving memories and counteracting fragmentation in an all-embracing design. In the process he has opened the way for solutions while at the same time maintaining aesthetic autonomy. And finally, the »Frieze of Life« is the demand for a total art form in which, through a renewal of aesthetics, a new future begins to shimmer beyond the metaphors of anxiety, pain and death.

The idea of a cycle of paintings with an overall design continued to dominate Munch's work in the second half of his life. The Linde Frieze of 1904, which was rejected by its commissioner, the Reinhardt Frieze of 1907 and the Freia Frieze of 1922 are more or less modest variations on the »Frieze of Life«. The more important works, however, including the decorations for the Oslo University Auditorium (unveiled in 1910) and the cycle of paintings, the »Frieze of Labor«, conceived in the 1920s and 1930s for the Oslo City Hall but never completed, the »Frieze of Labor«, can be seen as a twentieth century answer to the nineteenth century »Frieze of Life«: the conflicts of the individual stand in contrast to the conflicts of society.

List of Plates

Plates

All paintings reproduced in this volume, except Plate 13, *The Scream*, (oil and casein on cardboard), are oil on canvas.

Edvard Munch was twenty-three years old when he created this self-portrait in Oslo, using the rough, dry method of painting he had developed in *The Sick Child* (Plate 3). This method contrasts strongly with Norwegian Naturalism, in which fine brush work and wet paint were used to minutely describe each detail. During these years of searching, the young Munch was stimulated, encouraged, but also distressed by the Kristiania Bohème and their central figures Hans Jaeger and Christian Krohg.

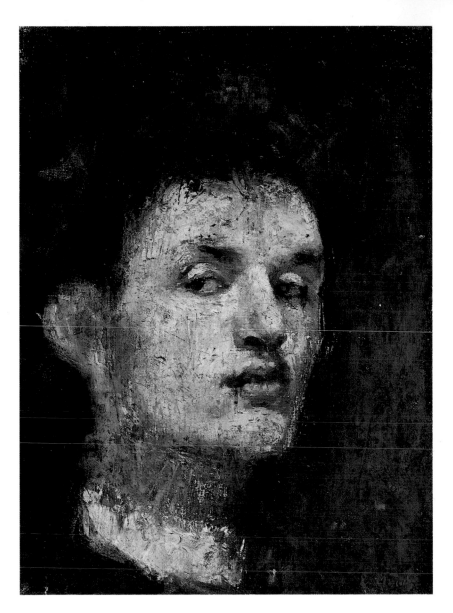

1 *Self-Portrait* 1886

33 x 24,5 cm

When the twenty-one-year-old Edvard Munch painted *Morning,* he was still operating in the tradition of Norwegian realism with its every-day motifs and, in particular, in the tradition of Christian Krohg, who had been his mentor two years before. The play of light, however, seems to have interested him more than the social situation. In a letter written in September 1884 Munch emphasized how difficult it had been to paint the numerous shades of white.[39] The same year the painting was completed, it was shown at the Oslo Autumn Exhibition. The critics commented that it was »remarkably tasteless«, »completely sketchy in its execution«, a »parody of art«; they were surprised that the public tolerated art of this kind.

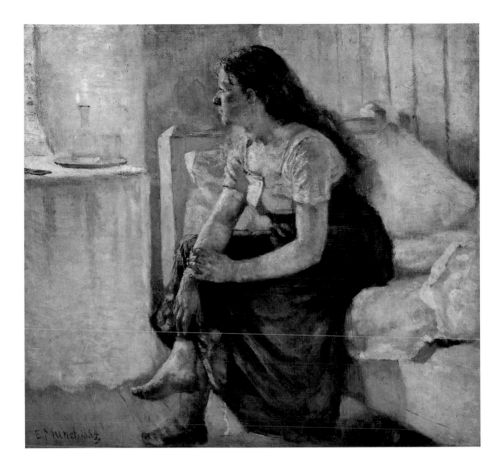

2 *Morning* 1884
96,5 x 103,5 cm

The models were Edvard Munch's Aunt Karen Bjølstad and the eleven-year-old Betzy Nielsen, whom he met while accompanying his father on a sick call. The theme of the picture is the memory of his sister Sophie's death; but beyond that dealing with past remembrances became the justification for a new subjective form of painting, as is evident in its freedom of pictorial expression. Munch: »It marked a breakthrough in my art – the genesis of most of my subsequent works lies in this picture.«[40]

Even fellow artists had difficulties with his style. The Norwegian naturalist Gustav Wentzel remarked, when he first saw this painting: »You paint like a pig, Edvard. You can't paint hands like that. They look like sledge hammers.«[41]

Nearly every ten years Munch painted variations of the same theme in an effort to deal with the present reality of his remembrance: repetition being a means of clarification and resolution of pain; in the process the reworking of themes became a new aesthetic category.

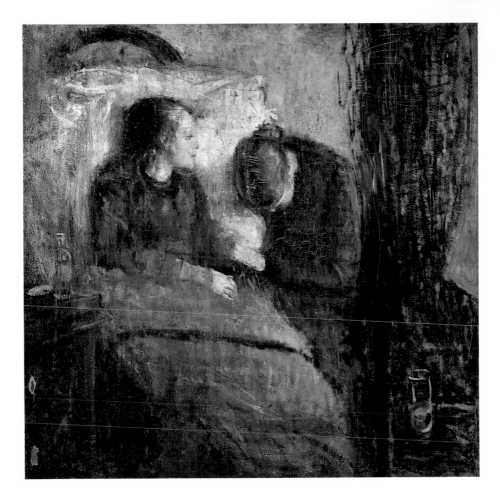

3 *The Sick Child* 1885/86
119 x 118,5 cm

Painted at Aasgaardstrand in Oslo Fjord, the picture shows Munch's sister in a solitary dialogue with nature, but at the same time she is still a part of nature. With no visible horizon, the water extends to the upper edge of the picture. A short time later – in *Melancholy* (Plate 9) – Munch depicted the break with nature, but here the unity can still be seen: the landscape describes the emotions of the silent figure.

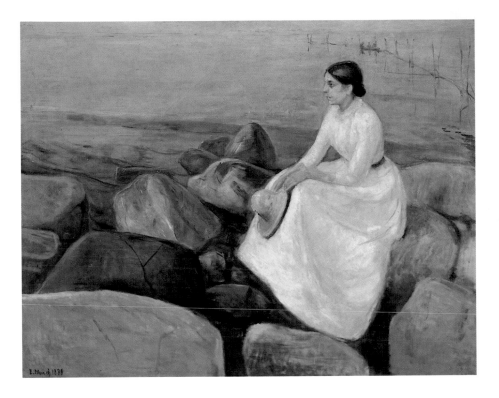

4 *Inger at the Sea Shore* 1889

126,4 x 161,7 cm

Nonchalant, supercilious, and with a trace of sarcasm on his lips, Hans Jaeger, the central figure of the Kristiania Bohème, rebel, social utopian sits in the corner of a sofa, a glass in front of him. In 1885 Jaeger had been put in prison for his novel *From the Kristiania Bohème*. After his release from a second prison term in February 1889, Jaeger was not allowed to return to his job as recording clerk in Parliament. Since he was also barred from resuming his study of philosophy at the University, he left Norway and struggled along in Copenhagen and Paris, and finally went to sea. This portrait, painted in 1889 immediately after Jaeger's release from prison and exhibited in Oslo, is an open act of solidarity. Munch: »He was someone I was always glad to see. He was one of the most congenial of the bohemians and he wrote the best Kristiania novel.«[42]

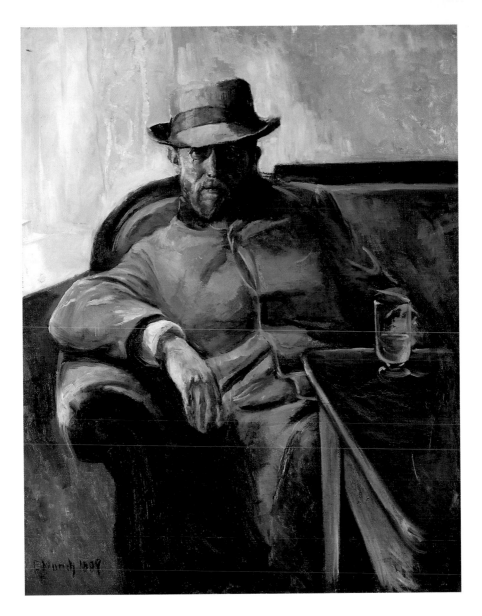

5 *Portrait of Hans Jaeger* 1889

109,5 x 84 cm

Two twentieth-century artists on this painting: »This band«, commented Joseph Beuys, »possesses a ghostly character. In addition it has, I feel, yet another meaning: here the proletariat is shown advancing. Later, in fact, it was the workers that Munch portrayed. And these pictures of the marching workers are preceded by a portrayal of the hounded bourgeoisie. The picture with the band contains an element of mass movement…Here anxiety already contains a societal component. It is the basso continuo in Munch's early memories. And art was the means of freeing himself from this anxiety.«[43] Georg Baselitz. »If it weren't for the two girls on the left … and the pedestrians on the right side, the band in the middle could be viewed as a barricade. This has a threatening element. One could think it was a demonstration or an execution. But this impression is broken up by the accompanying figures in the foreground … The threatening character of the crowd and the sketchy, jaunt head with the red parasol in the front that acts as a shifted focal point is certainly very unique and typical for Munch. From a naturalistic viewpoint there is no real explanation for the position of the parasol. It is a pronounced constructional element in the picture: the parasol and the cut-off head … The concrete becomes a phantom.«[44]

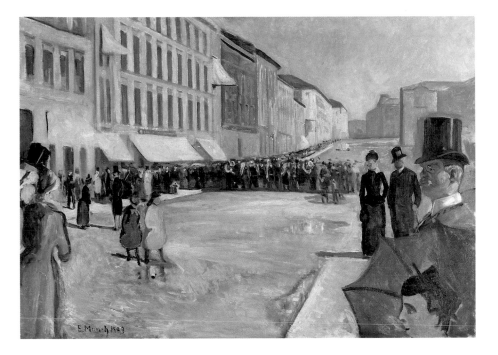

6 *Military Music on Karl Johansgate* 1889

102 X 141,5 cm

»For me life is like a window in a cell – I shall never enter the promised land.«[45] This small picture painted in France, which no doubt portrays his friend Emanuel Goldstein, marks a turning point in Munch's work. The view from the gloomy interior to life outside is a metaphor for Munch's future intention: to take memories and the inner reflections of reality as starting points and not reality itself.

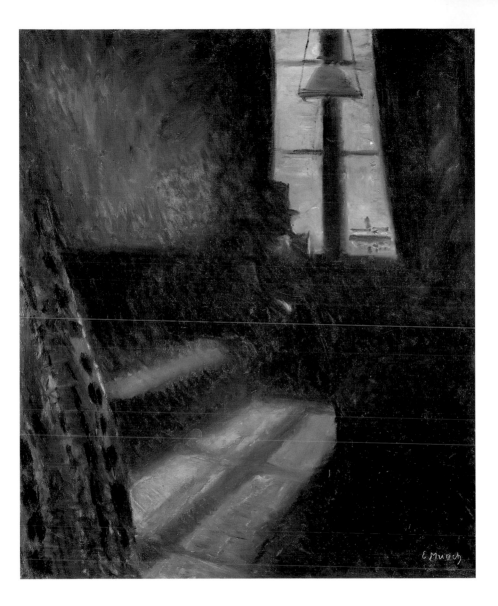

7 *Night in Saint-Cloud* 1890
64,5 x 54 cm

Karl Johansgate ist the main street of Oslo, and includes the Parliament Building (visible on the right of the picture), the central Storting Place, and the Grand Hotel, where the Kristiania Bohème met.

Specter-like burghers with sallow, featurless faces promenade in the city. Munch, who painfully experienced this social class's derision of his art, seems to be avenging himself with his mask-like portrayals, reminiscent of James Ensor. As Ensor himself said: »I was searching for consistently drastic effects, especially with the masks. I also liked these masks because they offended the public, which had treated me so poorly.«[46] Munch noted in 1891: »I feel that I am drifting further and further away from the kind of thing that the public likes – I feel that I will end up being even more outrageous.«[47]

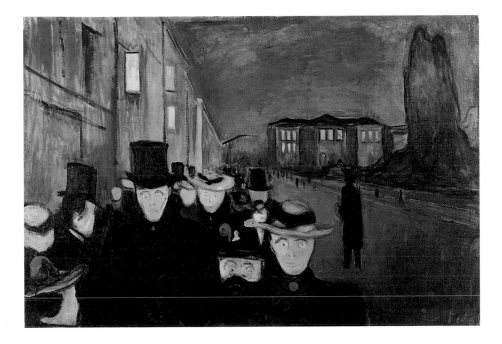

8 *Evening on Karl Johansgate* 1892
84,5 × 121 cm

When the painter Christian Krohg saw an earlier version of this picture at the Oslo Autumn Exhibition in 1891, he remarked: »A long shoreline traverses the picture ending in a wonderfully harmonious line. This is music … We should be grateful to Munch for the yellow color of the boat … and for the colors in general!« The violet and the vivid green are »patches in which we can lose ourselves and by contemplating we can become better human beings«; they »almost threateningly point to a new meaning for art.« And further on: »Has anyone ever heard such harmony in colors as in this picture … Perhaps it is more music than painting, but in any case brilliant music. Munch should be paid as a musician … We realize now, that Munch … is the first and only person to turn towards idealism, who dared to adapt nature or a model to the mood and to change them in order to reach something higher.«[48]

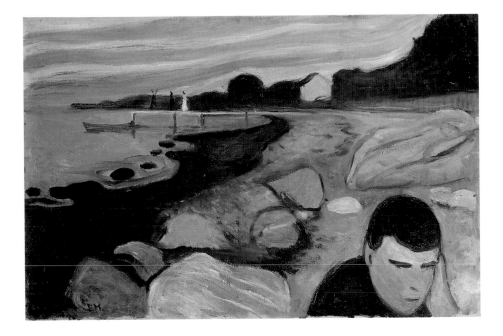

9 *Melancholy* 1891/92
65,5 × 96 cm

Together, with *The Sick Child* and *Puberty*, *The Day After* belongs to the first group of idiosyncratic paintings created by Munch in 1885/86. The first version, probably an answer to the painting with the same title exhibited in Oslo in 1883 by the naturalistic painter Gustav Wentzel, was lost; a few years later Munch reworked the motif. The theme, which had its origin in the ideas of the Kristiania bohemians, still caused an uproar when it was bought by the National Gallery in Oslo in 1908. »Now our citizens cannot take their daughters to the National Gallery. How much longer will Munch's harlot be allowed to sleep off her drunkenness in the state gallery?«[49]

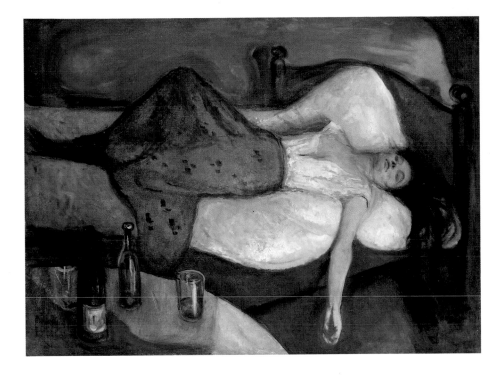

10 *The Day After* 1894

115 x 152 cm

The first version of this painting was also destroyed in 1886 by a fire in Munch's atelier; two new versions followed in 1893 and 1894 in Berlin. Stiff with anxiety, distressed by an overpowering shadow, the naked girl is mercilessly exposed to the observer. Is the shadow a sign of death? Then the painting would be more than just a psychogram of pubertal stress; it would also be an example of mankind's defenselessness, of existential anxiety and fear of death.

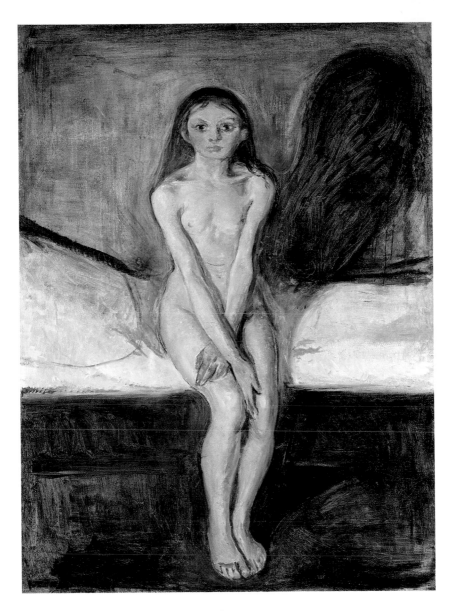

11 *Puberty* 1894
151,5 x 110 cm

In a stage-like composition the most important event, dying, remains hidden. The figures are paralyzed by their mourning. The family members are all present: father, aunt, sisters, brother, and Edvard himself behind Laura and Inger. When this picture was painted, Munch's father was, however, no longer living and the others were considerably older than they appear here. In Berlin, where the analysis of the psyche and the subconscious was being debated, Munch once again took up his familiar theme. When compared with *The Sick Child*, however, the differences are striking. Not death and dying, but the inner reaction of those left behind is remembered; this is why the dead child is not seen. The painting completes the transition from the depiction of outer drama to that of inner drama, although it is still portrayed in a kind of scenic statuary, as if taken from an Ibsen play.

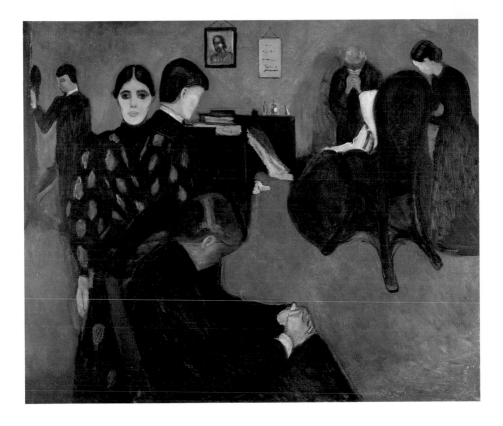

12 *Death in the Sickroom* 1893

134,5 x 160 cm

»I was going down the street behind two friends«, wrote Munch in 1892. »The sun went down behind a hill overlooking the city and the fjord – I felt a trace of sadness – The sky suddenly turned blood red. I stopped walking, leaned against the railing, dead tired – My two friends looked at me and kept on walking – I watched the flaming clouds over the fjord and the city – My friends kept on – I stood there shaking with fear – and I felt a great unending scream penetrate unending nature.«[50] Another passage: »I felt a loud scream – and I really heard a loud scream ... The vibrations in the air did not only affect my eye but my ear as well – because I really heard a scream. Then I painted *The Scream*.«[51]

In this painting with its sexless being, whose entire expression is concentrated in the gesture of screaming, in a blood-red landscape dramatically falling into the depths – a metaphor of death – Munch was able, as no other artist of his time, to express the pain and anxiety of the world in »artless nakedness«.[52] The basic constellation developed in *The Scream* (Plate 13) – the frontally-portrayed figures in the foreground, the whirlpool effect of the landscape, and the churned-up, threatening sky – is taken up again by Munch in *Anxiety*.

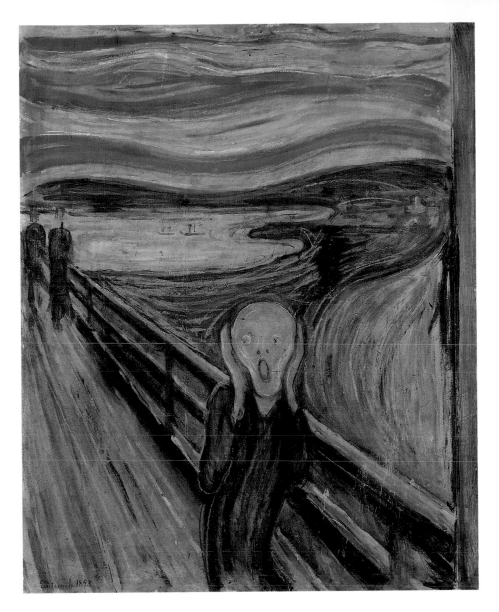

13 *The Scream* 1893

91 x 73,5 cm

Among the »Frieze of Life« paintings this scenery at Aasgaardstrand on Oslo Fjord often recurs: the horizontal lines of the seashore, the vertical lines of the schematically-painted, parallel tree trunks, and the sketchy reflection of the sun or moon.

In »Epipsychidion« Przybyszewski speaks of an enticing, mysterious voice on the beach at night. »Now I knew! It was the voice with bleeding eyes that I was searching for. It was the sea ... the voice of the sea.« Munch seems to have drawn his symbolic configuration from this context: the enticing voice of the sea which also brings death. The girl in her offer of love is the enticement of death. Her expression, Munch commented, was interested, full of hate and love, the eyes »warning of hate and death«.[53]

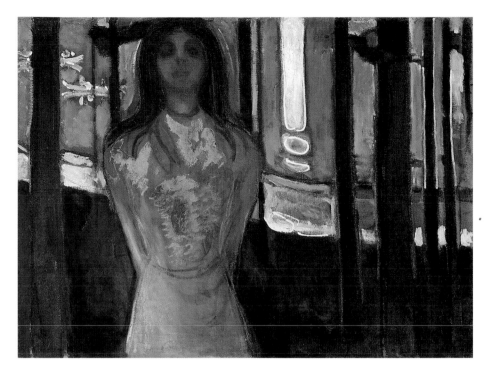

14 *The Voice* ca. 1893
90 x 118,5 cm

The motif, title and the dominating blue-green tones are reminiscent of Vincent van Gogh's painting of 1888 – only here the head alone is seen in front of a fjord landscape instead of the two figures in the Rhone countryside. Van Gogh's *Starry Night* (Arles, 1889) was shown in the independent artists' exhibition, where Munch saw it. His painting, created five years later, is both a homage to van Gogh and a pessimistic answer. Whereas the bright stars in van Gogh's painting are symbols of hope in a desperate situation; in Munch's painting darkness prevails without hope.

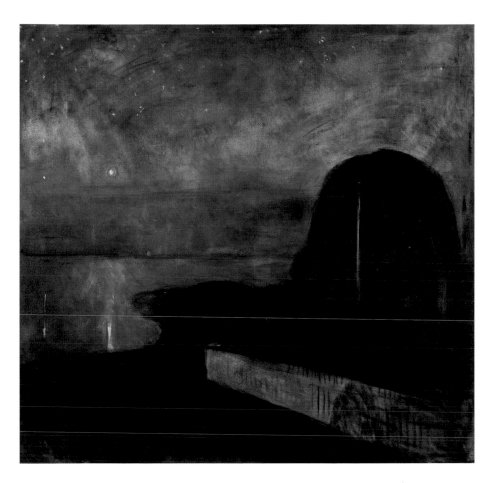

15 *Starry Night* 1893

135 × 140 cm

Just as *Starry Night* was influenced by van Gogh, so *The Storm* was influenced by Arnold Böcklin's *A Murderer Chased by the Furies*. Munch thought highly of Böcklin; he expressed himself enthusiastically on Böcklin's *Sacred Grove*, which he saw in the Hamburg Kunsthalle. While Böcklin proceeded in a narrative fashion in *Furies*, designing a fantasy landscape, and Munch began with an experience in nature at Aasgaardstrand, both share the same proclivity towards a psychological landscape that poses an enduring threat for the people lost in it. »Nature is not only visible to the eye – it is also the inner picture of the soul.«[54]

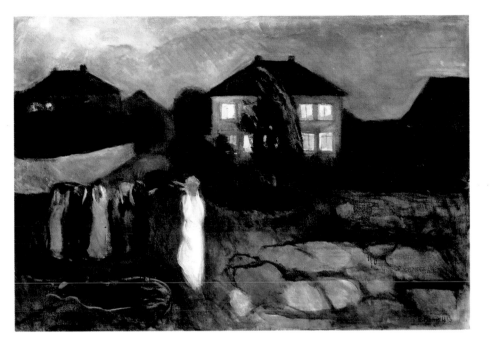

16 *The Storm* 1893
91,8 x 130,8 cm

The Norwegian Dagny Juell was most likely introduced to the »Ferkel« circle by Edvard Munch, the first woman in this male society, and an obviously perplexing and puzzling personality. One member recollected: »Ducha – as her friends called her – in her mid-twenties, was an imposing woman that all the men fell in love with ... she was intellectually acute and thoroughly ›modern‹ ... amongst the Berlin bohemians she was surrounded by a mystical aura.«[55] Much to Strindberg's chagrin, Dagny married the Polish writer Stanislaw Przybyszewski.

In the largely monochrome painting Dagny is portrayed less as a seductress or a modern intellectual than as a fragile, defenseless figure. Only the glowing face has ironic effervescence. Dagny Juell was murdered in Tiflis in 1901 at the age of thirty-four.

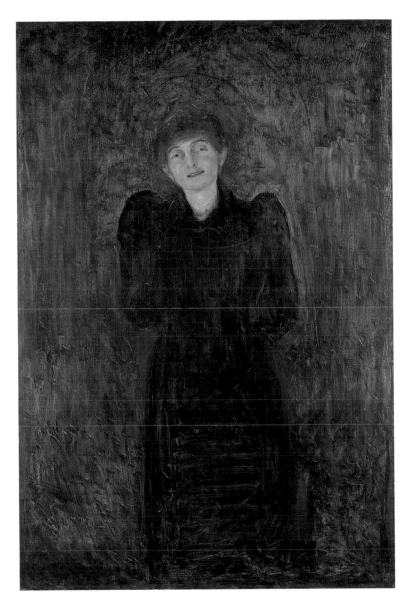

17 *Portrait of Dagny Juell Przybyszewska* 1893
148,5 x 99,5 cm

The woman portrayed frontally with her dress partially undone is tied by her long unraveled hair to the man who has turned away, anxiously burying his head. The scene is framed from below by a tree trunk, which in the upper left of the painting goes up in smoke, leaving only ashes behind. In 1902 in the Berlin Secession exhibition Munch included this painting, which he called *After the Fall*, in his »Frieze of Life« series as part of the group entitled »Blossoming and Fading of Love«. This painting portrays paradise lost, the state of having no illusions. The woman's hair is the only element which symbolically links man and woman: the remembrance of that which no longer exists or which only exists as pain.

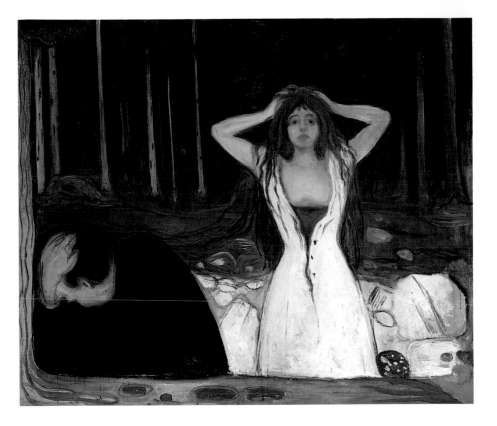

18 *Ashes* 1894

120,5 x 141 cm

The title itself seems to explain this painting. A figure sucking blood from someone else; the man is the victim, the woman drawing her dominating power from him at his cost. The motif recurs in Ibsen's »Hedda Gabler«, Strindberg's »Confession of a Fool«, and Przybyszewski's »De profundis«. But sketches made for this painting and the picture itself raise some doubts. Although the strong clutch of the woman's arm is constricting and arouses anxiety, the man is seeking protection and refuge; his left hand, roughly sketched, is not repulsing but holding on. Her hair falling over his head is an erotic symbol; it envelops him like a network of veins, holding him prisoner but at the same time unifying them. Thus, the painting portrays the yearning for union and the fear of the destructive power of love. Munch wrote: »He lay his head on her breast – he felt the blood pulsing in his veins – he listened to her heartbeat – He buried his head in her lap and felt two burning lips on the nape of his neck – it made his whole body tremble – a shiver of ecstasy – so that clasping her, he drew her closer.«[56]

In fact, the painting was originally entitled *Love and Pain*. It was called *Vampire* only after Przybyszewski's interpretation of 1894, in which he mistakenly placed it in the vampire topos, which was so popular at the end of the nineteenth century.

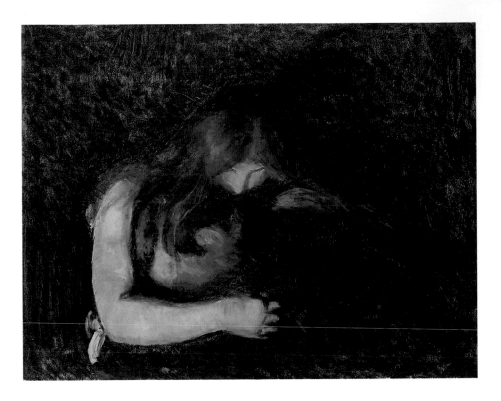

19 *Vampire* 1893/94
80,5 x 100,5 cm

» You are someone who goes through an alley of hands grasping at your naked body.«[57] Within his »Frieze of Life«, Munch saw this picture as a reference to male desire that inevitably leads to despair and death.

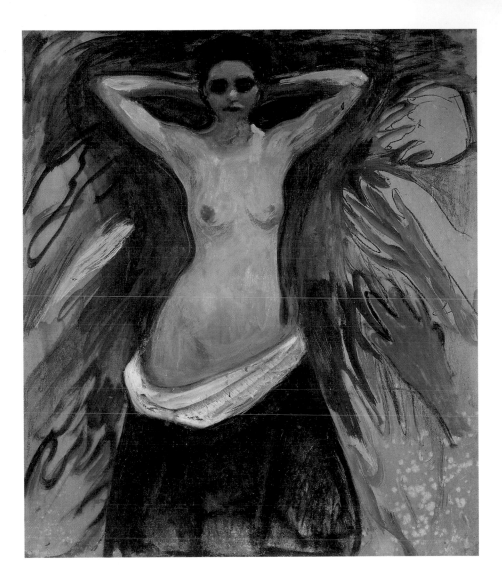

20 *Hands* ca. 1893/94

91 x 77 cm

Woman in Three Stages

The blond woman dressed in white, the naked red-head and the woman in black are reminiscent of traditional portrayals of life's phases; but they also represent the three divisions of a woman's nature. Munch wrote: »Woman is at once a saint, a whore, and a forelorn creature.«[58]

Off to one side, separated from the three women, stands a man with his eyes closed, turned aside, as if the three figures – as in *Jealousy* (Plate 29) – were in his thoughts. What separates him from the three women is a red plant-like form (»flower of blood«), symbol of pain and the loss of happiness. Thus, the main figure is probably the man, incapable of participating in the many-sidedness of woman's nature.

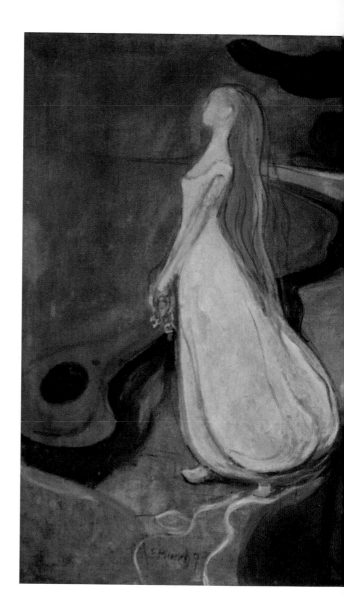

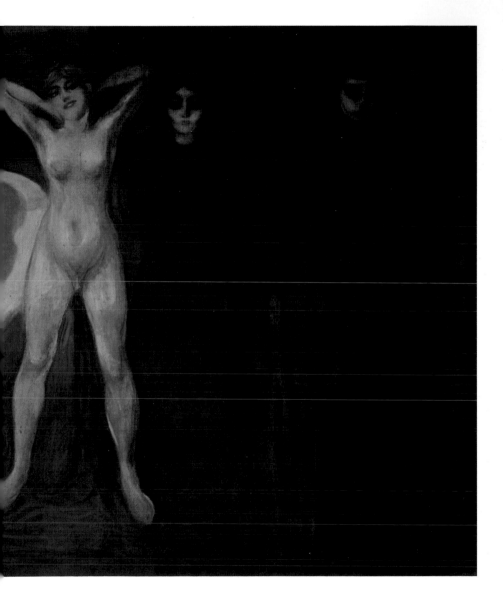

21 *Woman in Three Stages* 1894
164 x 250 cm

The first version of this painting was framed by painted or carved designs of sperm and embryos and was entitled either *Loving Woman* or *Conception*. But this painting does not deal solely with the virginity of a madonna or the orgiastic components involved in the ideas of conception or a loving woman, and it is hardly a persiflage. Munch wrote of this figure, »She is full of the world's beauty and pain«, because »death shakes hands with life.«[59]

In the 1890's when words like virgin, nun, whore, mother, venus, sphinx, femme fatale were invoked to explain the mysteriousness of the female nature, Munch, going beyond these topoi, created a painting of surrender and inclusion, love and death: the entire theme of the »Frieze of Life« in one configuration.

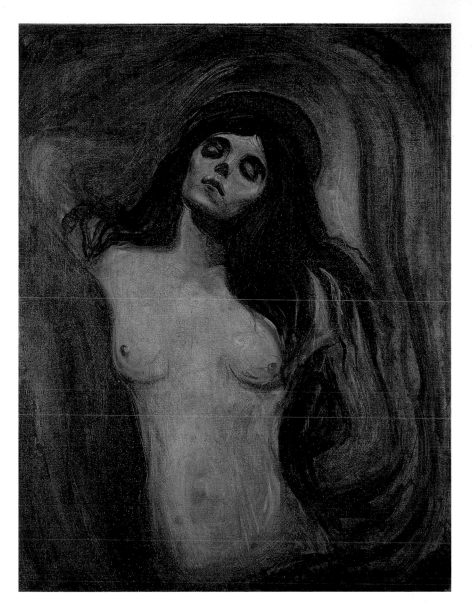

22 *Madonna* ca. 1894
136 x 110 cm

Munch used to expose his paintings to the weather for months in a specially built open-air atelier. The writer and art specialist Curt Glaser reported in 1927 after a visit to Munch: »While we slowly walked from painting to painting snow began to fall, and the glorious colors began to disappear behind a white blanket collecting in a thick layer on the surface of his paintings. Munch trudged along with a wisk of straw in his hand, sweeping clean first one, then the next so they became visible. I was somewhat concerned that the snow would damage the paintings. Munch, though, said ›No, no they're used to it.‹«[60]

For Munch the material character of the painting and also the effect of natural forces were of great importance: »It is as if my paintings needed some sun, dirt and rain; as a result the colors sometimes harmonize better. There's something hard about my paintings when they are fresh, which is why I worry about someone cleaning or varnishing them. A little dirt and a few holes suit them quite well.«[61] And he also said, »A good painting with ten holes is better than ten bad paintings without holes«.[62]

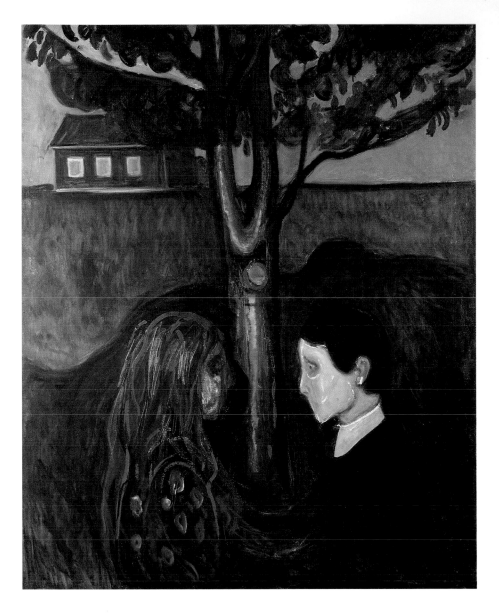

23 *Eye in Eye* 1894
136 x 110 cm

»Munch does not practice art for art's sake, which would just be a game for him, but for the sake of the terrible anxiety that haunts him« (Akseli Gallen-Kallela).[63]

»Art was the means for Munch to free himself of this anxiety. From it his new world of art arose and it was, of course, a world created anew« (Joseph Beuys).[64]

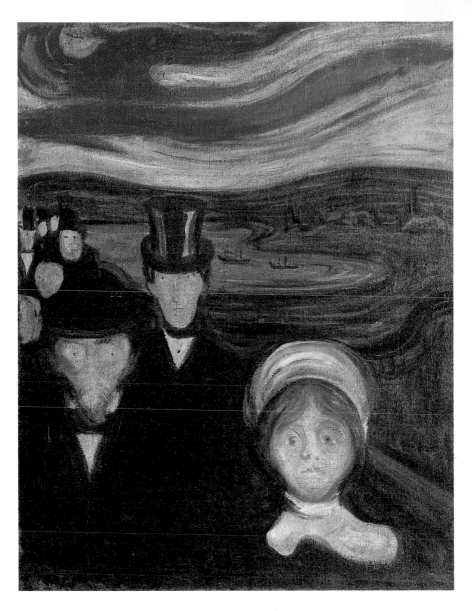

24 *Anxiety* 1894
94 × 73 cm

The bohemian with a cigarette in his hand, englufed in smoke, suggestive of the intellectual's milieu. No concrete attribute characterizes the figure as an artist, but the freely-used, evocative pictorial means describe him: a modern artist who faces challenges, sensitively waiting, and conscious of his superior abilities.

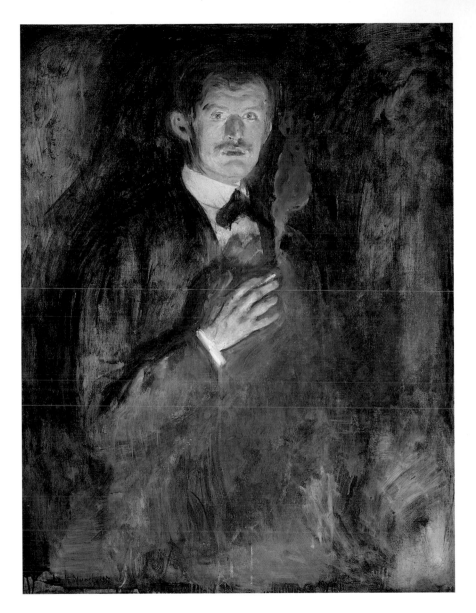

25 *Self-Portrait with Cigarette* 1895
110,5 x 85,5 cm

The art historian Julius Meier-Graefe, one of the most important proponents of Modernism before World War I, met Munch in the Berlin »Ferkel« circle. Meier-Graefe was initially co-editor of the journal »*Pan*«, for which several writers from the »Ferkel« group worked. As early as 1894 he wrote an article about Munch in Przybyszewski's book on the Norwegian painter. After the Berlin period he continued to see Munch and Strindberg in Paris. In 1904 his »Historical Development of Modern Art« appeared with a chapter on Munch. In this transparent portrait Meier-Graefe appears to be less a friend and sensitive companion than a dignified and at the same time austere authority – perhaps a reflection of his reserved attitude towards Munch's work.

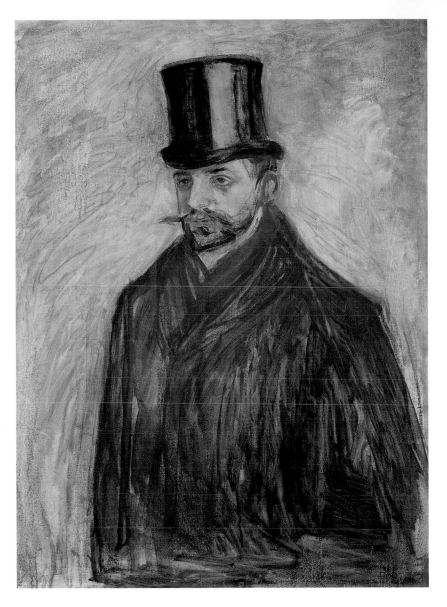

26 *Portrait of Julius Meier-Graefe* ca. 1895

100 × 75 cm

»The motif ... goes back to the remembrance of his sister Sophie's death. She lies in bed, her hands folded together. On her right the anxious family is gathered; only Edvard Munch is missing. We do not see the dying Sophie, but through the eyes of the artist, we see and we portend what she portends. The identification with the dying person forces the observer to take part in the death struggle« (Arne Eggum).[65]

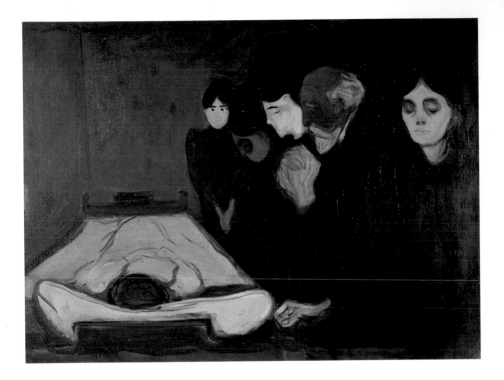

27 *At the Deathbed* 1895
90 x 125 cm

In an early study, a drawing from 1889 entitled *Adieu*, the couple was portrayed in a studio. In the 1892 version the couple stood on the right next to a window which dominated the painting and looked onto a street. In the final version (1897) the couple has been placed in the center, both heads dissolved into one. Here various levels of interpretation can be discerned: departure, union, engulfment. Love for Munch always goes hand in hand with destruction.

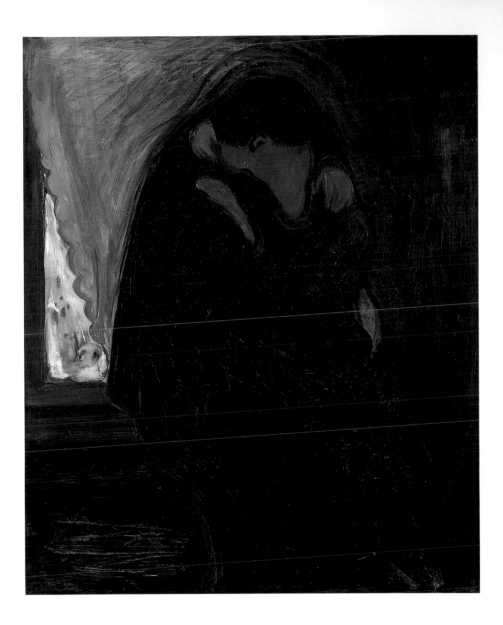

28 *Kiss* 1897
99 x 81 cm

» We desire something other than mere copies of nature. Nor is it a matter of painting beautiful pictures for living-room walls. We should be trying, even if we do not succeed, to establish a foundation for art capable of giving mankind something. Art which takes and gives. Art created out of the heart's blood« (Edvard Munch in the 1890s).[66]

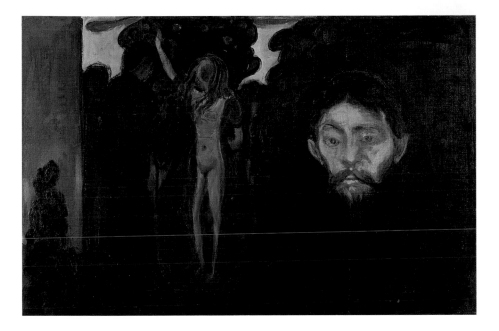

29 *Jealousy* 1895
67 x 100 cm

»Deep violet darkness fell over the earth – I sat under a tree whose leaves began to turn yellow and to wilt – They had sat next to me – she had rested her head on mine – her blood-red hair entwined me, wrapped around me like blood-red snakes – its finest strands got caught in my heart – then they got up – I don't know why – and moved slowly towards the sea – farther and farther away – then something strange happened – I felt invisible strands between us – I felt invisible strands of her hair enveloping me – and thus, when she had disappeared beyond the sea – I felt the pain, my heart was bleeding – because the strands could not be cut.«[67]

Munch's numerous notes are neither descriptions nor interpretations of his paintings. They record nervous impressions, experiences, phantasies, which then acted as an impetus for his work. Only in this way do they contribute to an understanding of the paintings.

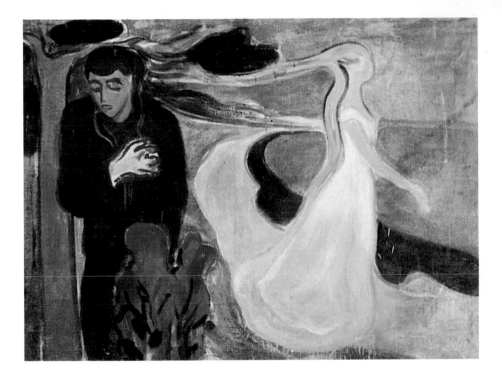

30 *Separation* ca. 1896
96,5 x 127 cm

The Dance of Life

The Dance of Life belongs to one of the last paintings which Munch added to his »Frieze of Life«. The two rigid figures and the couple in the foreground are set against burlesque couples in the background, making the figures in the foreground appear to be outcasts. Munch wrote in an autobiographical note: »I danced with my first love; it was a memory of her. Towards us came the woman with blond curly hair who wanted to take away the flower of love ... over there on the other side, dressed in black, she watches the dancing couple, mourning. She is an outsider just as I was excluded from her dance; and in the background the frantic mob in wild embracements.«[68] The solitary individual who feels excluded from society, incapable of participating in love and amusement: for Munch this is also an image of the artist's situation.

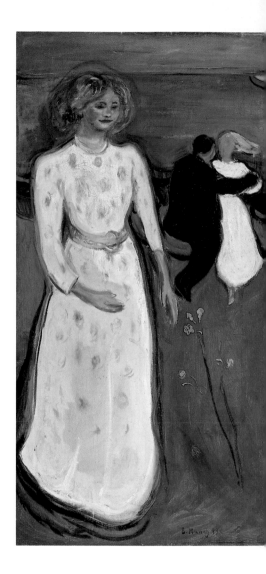

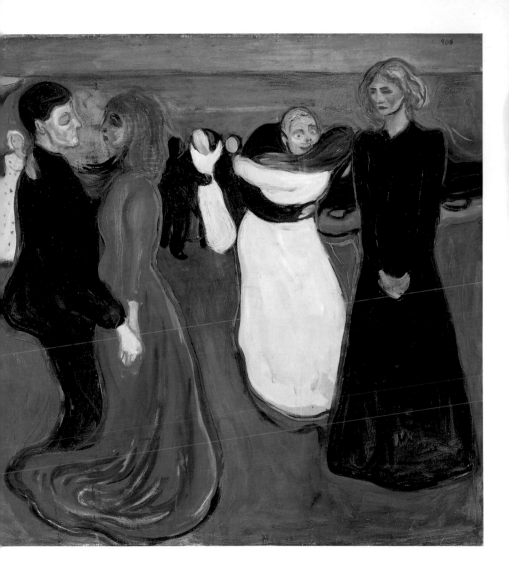

31 *The Dance of Life* 1899/1900
125,5 x 190,5 cm

Munch was inspired to paint this picture after seeing his sister again who had suffered from severe depression since her childhood; several sketches show her empty look with widely opened eyes, cut off from the world, lost in herself. Munch's convalesence in a sanitorium also played a role in the creation of this painting. There Munch noted: »When the winter sun which lay low on the horizon shone through the window – the room was ablaze with red and yellow – The yellow wooden walls turned into fire and the brown ceiling became blood – The light and the colors penetrated my soul and my body, in which my sick blood flowed. Melancholy ... I ran out to escape the eerie creature.«[69]

The picture is the attempt to deal with the invisible psychic forces in Laura and his own oppressive feeling of already carrying the seeds of insanity within himself. Munch developed his own iconography of insanity in this picture: the cramped gesture of the woman, staring past the observer, the steepness of the floor and table–top, the blood-red table with brain-like configurations, the poisonous yellow reflection of the outside world in the interior of the room.

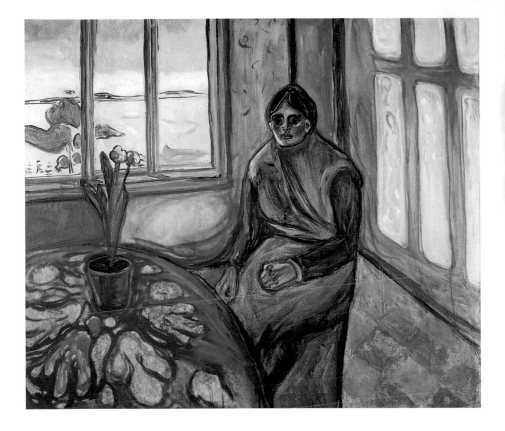

32 *Melancholy (Laura)* 1899
110 x 126 cm

The abrupt appearance of the head portrayed frontally in the foreground is reminiscent of *Jealousy* (Plate 29), the dramatically moving path suggests the metaphors of death in *The Scream* (Plate 13) and the blood-red house recalls the iconography of insanity in *Melancholy* (*Laura*) (Plate 32). Something ghastly has happened or will happen; what exactly remains unclear. A state of terror is evoked. The figure stares rigidly at the viewer as if he were demanding a reaction from him: an appeal to overcome the terror in the world.

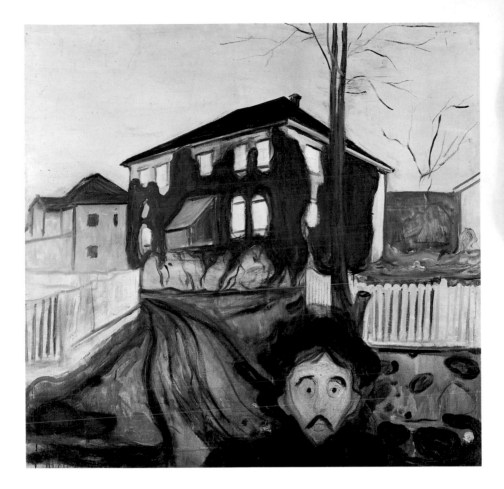

33 *The Red Vine* 1898/1900

119,5 × 121 cm

The scenery, today hardly changed, is the pier at Aasgaardstrand, a few steps from Munch's atelier. The painting, however, does not show a quaint village scene. The bridge and the path leading from it press into the depths; the figures looking into the blackish water suggest melancholy and foreboding. The emotional state of the girls is not portrayed but that of the painter. Paul Gauguin once wrote (1892): »My entire existence is thus: I stand at an abyss and do not fall into it.«[70] And Munch: »I always find myself drawn inexorably back towards the chasm's edge and there I shall walk until the day I finally fall into the abyss.«[71]

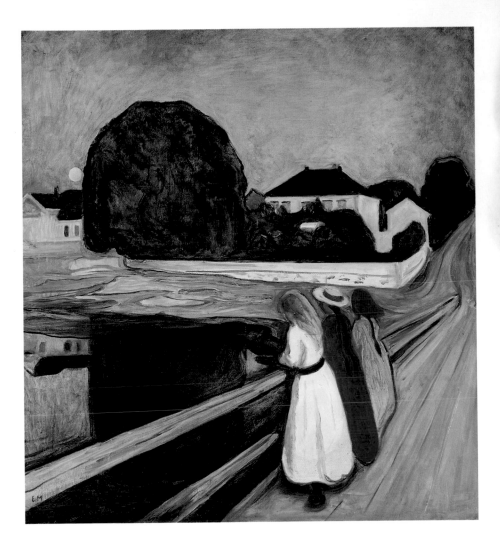

34 *Three Girls on the Bridge* 1900
136 x 125,5 cm

Notes

The abbreviation OKK with the corresponding inventory number refer to notes made by Edvard Munch, kept in the Munch Museum, Oslo. These notes have not yet been published in their entirety and are only partially translated from Norwegian. They are quoted here either from the originals (translated by the author), or according to various available translations.

1. OKK T 2782
2. Ibid.
3. Stanislaw Przybyszewski (ed), *Das Werk Edvard Munch*, Berlin 1894, S. 23–24
4. Arne Brenna, »Hans Jaeger og Edvard Munch. Billedkunsten og litteraturen«. In: *Nordisk Tidsskirft* 52, 1976, p. 92
5. Ola Hansson: *Das junge Skandinavien. Vier Essays*, Dresden and Leipzig 1891, p. 184
6. OKK N 65
7. OKK N 29
8. Notes from Saint-Cloud around 1890, quoted in Gösta Svenæus: *Edvard Munch. Im männlichen Gehirn*, Lund 1973, vol. 1, p. 37–38. This section is a summary of the fuller treatment of *The Sick Child* which I presented in my book (see Bibliography).
9. OKK N 45
10. Note in the Munch Museum in Oslo, quoted in *Munch und Ibsen*, Exhibition Catalogue, Zürich 1976, p. 14
11. OKK T 2734
12. Edvard Munch, *Livsfrisens tilblivelse*, n. d. (ca. 1929), p. 10
13. Ibid., p. 1. This remark comes from *Livsfrisens tilblivelse* from 1890 (the dating is confirmed in OKK T 2785 from 1925)
14. Ibid., p. 10
15. OKK T 2760
16. OKK T 2759
17. Emanuel Goldstein, »Kammeratkunst«. In: *København* of 8 February 1892, quoted in Reinhold Heller, *Munch. His Life and Work*, Chicago and London 1984, p. 67.
18. *Edvard Munchs brev. Familien* edited by Inger Munch, Oslo 1949, p. 120
19. Ibid., p. 123
20. *Kunstchronik* NF IV/5, 1892/93
21. *Berliner Tageblatt* of 8 November 1892
22. *Kunst für Alle* IX/8 of 15 January 1894
23. *Edvard Munchs brev. Familien* op. cit., p. 122
24. Stanislaw Przybyszewski, *Erinnerungen an das literarische Berlin*, Munich 1965, p. 192
25. For Scandinavianism in Berlin and the onsetting subjectivism see: Uwe M. Schneede, »Das Innere Malen. Zu den Wechselwirkungen zwischen Skandinavien und Deutschland«. In: *Im Lichte des Nordens. Skandinavische Malerei um die Jahrhundertwende*, Exhibition Catalogue, Kunstmuseum Düsseldorf

1986, p. 10–26

26. Quoted in Gösta Svenæus, op. cit., vol. 1, p. 82

27. A thorough-going study of the »Frieze of Life« can only be found in the unpublished dissertation of Reinhold Heller (*Edvard Munch's ›Frieze of Life‹: Its Beginnings and Origins*, Indiana University 1968). The title of the catalogue for an exhibition at the Berlin National Gallery in 1978, *Edvard Munch. Der Lebensfries*, is misleading: here the subject matter is the »Reinhardt-Frieze« of 1907

28. OKK T 2734

29. OKK T 2732

30. OKK N 30

31. Edvard Munch, »Livs-frisen«. In: *Tidens Tegn* of 15 October 1918

32. Edvard Munch in *Tidens Tegn* of 19 October 1918

33. Ibid.

34. Draft for a letter to Rasmus Meyer without inventory number in the Munch Museum, Oslo.

35. *Livsfrisens tiblivelse*, op. cit., p. 4

36. »Not just Pictures. Joseph Beuys on Edvard Munch« (Interview with Dieter Koepplin). In: *Edvard Munch. Sein Werk in Schweizer Sammlungen,* Exhibition Catalogue, Kunstmuseum Basel 1985, p. 142.

37. OKK T 2748 b

38. OKK N 45

39. Letter to Olav Herman Paulsen of September 1884, without inventory number in the Munch Museum, Oslo.

40. *Livsfrisens tilblivelse*, op. cit., p. 10

41. Quoted in Rolf Stenersen, *Close-Up of a Genius*, Oslo 1972, p. 17

42. Letter of 21 January 1910 to Jappe Nilssen, quoted in *Edvard Munchs kriseår. Belyst i brever*, edited by Erna Holmeboe Bang, Oslo 1965, p. 78

43. Beuys Interview, op. cit., p. 135.

44. »Invented Pictures. George Baselitz on Edvard Munch« (Interview with Dieter Koepplin). In: *Edvard Munch. Sein Werk in Schweizer Sammlungen*, Exhibition Catalogue, Kunstmuseum Basel 1985, p. 163–164.

45. OKK T 2747

46. Ensor's letter from late 1894/early 1895, quoted in *Ensor – ein Maler aus dem späten 19. Jahrhundert*, Exhibition Catalogue, Württemberg Kunstverein Stuttgart 1972, p. 37

47. Note of 30 August 1891, quoted in Ragna Stang, *Edvard Munch – The Man and the Artist*, London 1979, p. 79.

48. Quoted in Jens Thiis, *Edvard Munch*, Berlin 1934, p. 22

49. Quoted in Rolf Stenersen, *Close-Up of a Genius*, Oslo 1972, p. 17

50. OKK T 2367

51. OKK T 2785

52. Gösta Svenæus, op. cit., vol. 1, p. 119

53. OKK T 2601

54. OKK T 2785

55. Franz Servaes, quoted in Wladyslawa Jaworska, »Munch und Przybyszewski«. In: *Edvard Munch. Probleme – Forschungen – Thesen*, edited by Henning Bock and Günter Busch, Munich 1973, p. 51

56. OKK T 2771

57. OKK T 2801

58. Quoted in Pål Hougen, *Farge på trykk*, Exhibition Catalogue, Munch Museum, Oslo 1968, p. 12

59. OKK T 2782
60. *Magdeburger Zeitung* of 15 March 1927
61. Quoted in Rolf Stenersen, op. cit., p. 41. On this topic see also: Jan Thurmann-Moe, »Anmerkungen zu Munchs Maltechnik«. In: *Edvard Munch* Exhibition Catalogue, Essen and Zürich 1987/1988, p. 89–99
62. Quoted in Johan H. Langaard and Reidar Revold, *Edvard Munch. Meisterwerke aus der Sammlung des Künstlers im Munch-Museum Oslo*, Stuttgart 1963, p. 62
63. Quoted in Ragna Stang, op. cit., p. 90
64. Beuys Interview, op. cit., p. 135
65. Arne Eggum in: *Munch. Liebe, Angst, Tod*, Exhibition Catalogue, Bielefeld 1980, p. 209
66. Quoted in *Edvard Munch, Arbeiterbilder 1910-1930*. Exhibition catalog, Kunstverein in Hamburg 1978, p. 28
67. OKK T 2782
68. OKK T 2759
69. OKK T 2733
70. Letter of June 1892 to Georges Daniel Montfreid
71. Quoted in Ragna Stang, op. cit., p. 24

Selected Bibliography

Eggum, Arne: *Edvard Munch. Paintings, Sketches and Studies*, New York 1984

Eggum, Arne: *Munch og Fotografi*, Oslo 1987

Heller, Reinhold: *Munch. His Life and Work*, Chicago and London 1984

Langaard, Johan H. and Reidar Revold: *Edvard Munch. Fra år til år. En håndbook* (»A year by year record of Edvard Munch's Life. A Handbook«), text in Norwegian and English, Oslo 1961

Edvard Munchs brev. Familien, edited by Inger Munch, Oslo 1949

Edvard Munch. Probleme – Forschungen – Thesen, edited by Henning Bock and Günther Busch, Munich 1973

Edvard Munch and Henrik Ibsen, Exhibition Catalogue, Kunsthaus, Zürich 1976

Edvard Munch. Symbols and Images, Exhibition Catalogue, National Gallery of Art, Washington 1978

Edvard Munch. Liebe, Angst, Tod, Exhibition Catalogue, Bielefeld 1980

Edvard Munch. Höhepunkte des malerischen Werks im 20. Jahrhundert, Exhibition Catalogue, Kunstverein in Hamburg, Hamburg 1984

Przybyszewki, Stanislaw: *Das Werk des Edvard Munch*, Berlin 1894

Schneede, Uwe M.: *Edvard Munch. Das kranke Kind. Arbeit an der Erinnerung*, Frankfurt/M. 1984

Stang, Ragna: *Edvard Munch – The Man and the Artist*, translated by Geoffrey Culverwell, London 1979

Svenæus, Gösta: *Edvard Munch. Im männlichen Gehirn*, 2 vols., Lund 1973

Chronology

1863 Born in Løten/Hedmark, Norway, son of the doctor Christian Munch and his wife Laura Cathrine. The following year the family moves to Oslo, then called Christiania (after 1877 Kristiania).

1868 Mother dies, her sister Karen Bjølstad runs the household

1879/80 Attends Technical School in Oslo to study engineering

1880 Pupil at Royal School of Drawing in Oslo

1882 Rents a studio together with six other artists in the center of Oslo; receives advice from Christian Krohg

1883 First participation in an exhibition in Oslo

1884 Becomes involved in the circle of Oslo Bohème

1885 Three weeks' stay in Paris, supported by Frits Thaulow

1888 Fall visit to Aasgaardstrand where he then regularly spends his summers

1889 First one-man exhibition in Oslo. October in Paris where he attends Léon Bonnat's art school; stay in Saint-Cloud outside of Paris

1890 Return to Oslo in May via Antwerp, in November trip to Le Havre

1891 Goes to Paris, Nizza. Summer in Norway, autumn in Paris and Nizza

1892 One-man exhibition in Berlin (Verein Berliner Künstler), which is forcibly closed down after one week, then shown in Düsseldorf, Cologne, and again in Berlin

1893 Meets Scandinavian and German artists and writers in the »Ferkel« circle in Berlin

1894 Continues to lives in Berlin. First etchings. Stanislaw Przybyzewski publishes his biography on Munch including articles by Franz Servaes, Willy Pastor, Julius Meier-Graefe and himself.

1895 Berlin, then Paris, Norway and again Paris

1896/97 Mostly in Paris, then Brussels. Buys a house in Aasgaardstrand. Numerous travels throughout Europe also during the following years, often because of exhibitions

1903 Berlin, Leipzig, Paris, Grez-sur-Loing, Lübeck

1904 Berlin, Lübeck, Weimar, Kopenhagen. Dr. Max Linde rejects the frieze he commissioned

1906 Thüringen. Designs scenery for Ibsen's play *Ghosts* in Max Reinhardt's Kammerspiele in Berlin

1907 Designs scenery for Ibsen's *Hedda Gabler* for the Deutsches Theater, Berlin and a frieze for the foyer of Max Reinhardt's Kammerspiele

1908 National Gallery in Oslo buys several paintings. Nervous breakdown, stay in Copenhagen clinic until Spring 1909

1909 Rents the residence »Skrubben« in Kragerø. Rasmus Meyer of Bergen buys several paintings. Participation in the competition for the decoration of the Oslo University Auditorium

1910 Buys Nedre Ramme in Hvitsten on Oslo Fjord

1916 Buys Ekely estate in Skoyen near Oslo where Munch lives until his death. Unveiling of the murals at the Oslo University

1922 Paints murals for the canteen of the Freia Chocolate Factory in Oslo. Retrospective exhibition at the Kunsthaus in Zürich

1927 Retrospective exhibitions at the Kronprinzenpalais in Berlin and the National Gallery in Oslo

1928 Designs of a »Workers Frieze« for the future Oslo Town Hall; 1936 Munch gives up work on it

1937 Munch's works branded degenerate and removed from numerous German museums, most of them sold to the art dealer Harald Holst Halvorsen, who auctioned them in Oslo

1944 Munch dies in Oslo

Index of Persons